Boehm.

FEB 28 2012 Boston state of

Massachu

cool stuff every

and the State of MASSACHUSETTS

It's old with lots of new! It's fun

with lots to do!

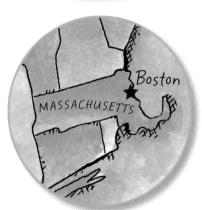

he places where you live and visit help shape who you become. So find out all you can about the special places around you!

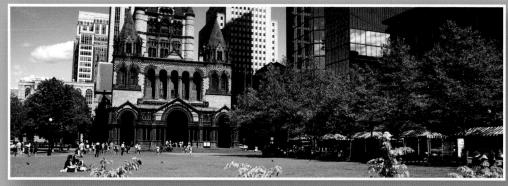

Trinity Church stands in Copley Square in the Back Bay neighborhood of Boston.

CREDITS

Series Concept and Development

Kate Boehm Jerome

Series Design

Steve Curtis Design, Inc. (www.SCDchicago.com); Roger Radtke, Todd Nossek

Reviewers and Contributors

Julia J. Mize, Acting Education Specialist, Boston NHP; Connie Bodner, Ph.D, senior researcher; Peter DiForte Jr., CelebrateBoston.com; Judy Elgin Jensen, research and production; Mary L. Heaton, copy editor

Photography

Cover(a), Back Cover(b), i(b) @ Alex Staroseltsev/Shutterstock; Cover(c), Strange But True (c) @ hawkeye978/Shutterstock; Cover(d), Strange But True (d), xvi(d), g) @ Jorge Salcedo/Shutterstock; Cover(c), Strange But True (e) @ hawkeye978/Shutterstock; Cover(d), Strange But True (a), xvi(d), g) @ Jorge Salcedo/Shutterstock; iii @ Caitlin Mirra/Shutterstock; Spotlight (background) @ Filipe B. Varela/Shutterstock; Spotlight (a) @ Artifan/Shutterstock; By The Numbers (b), xvi(c) @ Christopher Penler/Shutterstock; By The Numbers (c) Courtesy Boston Pops Fireworks Spectacular/Photo by Jay Connor; By The Numbers (d) @ ibsky/Shutterstock; Sights and Sounds (a) @ Alenavlad/Shutterstock; Sights and Sounds (b) @ Gabrielle Hovey/Shutterstock; Sights and Sounds (c) @ Zorylee Diaz-Lupitou/Shutterstock; Sights and Sounds (d) @ Susanna Fieramosca Naranjo/iStockphoto; Sights and Sounds (e) @ Ilya D. Gridnev/Shutterstock; Sights and Sounds (f) Courtesy Boston Duck Tours; Sights and Sounds (g), xvi(a) @ Jesse Kunerth/iStockphoto; Strange But True (b) @ SharpShooter/Shutterstock; Strange But True (d) Courtesy CelebrateBoston.com; Marvelous Monikers (b) @ Renato Foti/iStockphoto; Marvelous Monikers (c) By Tim Linscott; Marvelous Monikers (d) @ Courtesy the Museum of Science, Boston; Dramatic Days (a) From Wikipedia; Dramatic Days (c,d) @ Boston Globe/David L. Ryan/Landov; xvi(b) @ Israel Pabon/Shutterstock; xvi(e) @ Stephen Orsitlo/Shuttertock; xvi(f) @ Lorraine Kourafas/Shuttertock

Illustration

i @ Jennifer Thermes/Photodisc/Getty Images

Copyright © 2011 Kate Boehm Jerome. All rights reserved. No part of this book may be used or reproduced in any manner without written permission except in the case of brief quotations embodied in critical articles and reviews.

ISBN 978-1-4396-0099-3

Library of Congress Catalog Card Number: 2010935890

Published by Arcadia Publishing, Charleston, SC For all general information contact Arcadia Publishing at:

Telephone 843-853-2070 Fax 843-853-0044

Email sales@arcadiapublishing.com

For Customer Service and Orders: Toll-Free 1-888-313-2665

Visit us on the Internet at www.arcadiapublishing.com

Table of Contents

Boston

Spotlight on Boston By the Numbers Sights and Sounds Strange But True Marvelous Monikers Dramatic Days

Massachusetts

What's So Great About This State	1
The Land	2
The Coastal Lowland	4
Uplands and Valleys	6
Ponds, Lakes, and Rivers	8
The History	10
Monuments	12
Museums	14
Forts	16
The People	18
Protecting	20
Creating Jobs	22
Celebrating	24
Birds and Words	26
More Fun Facts	28
Find Out More	30
Massachusetts: At a Glance	31

Spotlight Boston

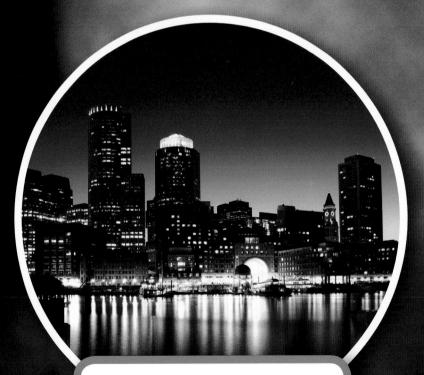

Boston is the largest city in New England and the capital of Massachusetts.

The population within city limit. is around 645,000. But millions more live in the metropolitan area—which includes the areas surrounding the city.

Are there any pro sports teams in Boston?

Absolutely! Boston is an incredible sports town whose fans support such teams as the Red Sox (baseball), Celtics (basketball), New England Patriots (football), and Bruins (hockey).

What's one thing every kid should know about Boston?

Boston is one of the oldest cities in the country. It was founded in 1630 by English Puritan colonists, led by John Winthrop.

her eight ducklings through the Boston Public Garden to honor the author of the classic children's story *Make Way for Ducklings*.

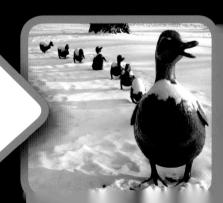

By The Numbers

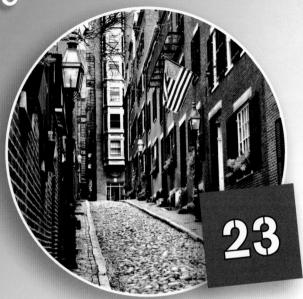

Twenty-three neighborhood areas are listed on the city's official web site so it's no wonder Boston is known as the "city of neighborhoods." And, like Beacon Hill in the photo, each neighborhood has its own special history and character that make it unique.

221

The Bunker Hill
Monument stands 221
feet high at Breed's
Hill—the site of the
first major battle
between British and
Patriot forces in the
Revolutionary War.

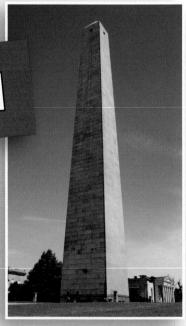

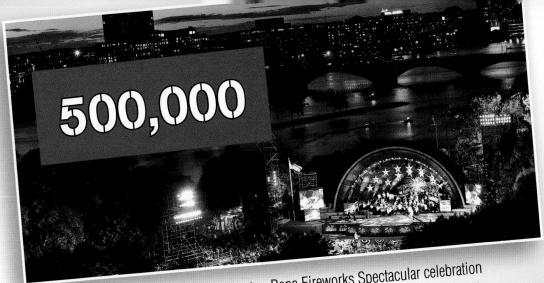

About half a million people attend the Boston Pops Fireworks Spectacular celebration each year. (And millions more tune in on TV!) The Boston Pops Orchestra performs a concert at the outdoor Hatch Shell ... then fireworks explode over the Charles River.

The Leonard P. Zakim Bunker Hill Memorial Bridge is 1,432 feet long. It spans the Charles River and is one of the widest cable-stayed bridges in the world.

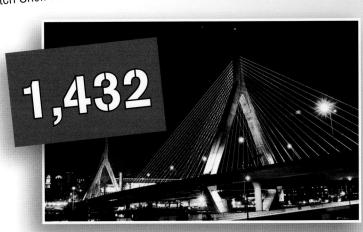

More Numbers!

The year when Boston Common land first became public.

Now a lovely park, the Common was once used for everything from livestock grazing to public hangings.

According to the city's official web site, there are 34 colleges and universities in Boston. (This number can change...but students are always a big part of the city!)

colleges and universities in 2009 and part of the city! change...but students are always a big part of the city!

That was the year the first Boston Marathon was run, which makes it the world's oldest annual marathon.

Sights Sound Sound

Hear

...beautiful music played by one of the greatest orchestras in the world. The Boston Symphony Orchestra was organized in 1881, and it's still making music today.

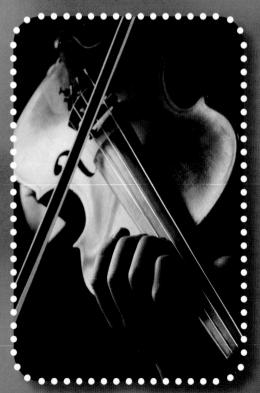

Smell

...the Italian sausages grilled on game day at Yawkey Way—the street just outside of Fenway Park.

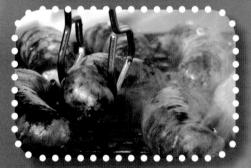

...the spring flowers in the Boston Public Garden. (Don't forget to admire the statue of George Washington while you're there!)

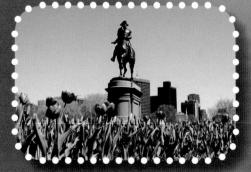

See

...jugglers, musicians, and many other street performers entertain the crowds at the Faneuil Hall Marketplace.

...the city from both land and water—by duck! A "duck tour" is taken on a World War II-type amphibious vehicle that travels the streets of Boston but can also float in the Charles River.

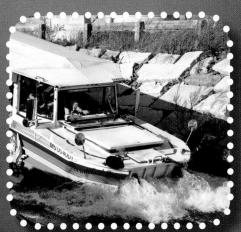

Explore

...the New England Aquarium. It's home to more than eighty penguins—including some like the rockhopper below.

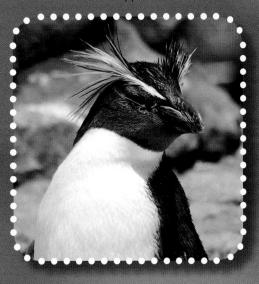

...Boston's Freedom Trail—a walking trail that connects 16 historical sites around the city. (A red brick or painted line along the ground serves as a built-in guide!)

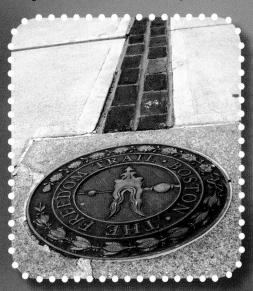

Sights and Sounds

SIRAISE

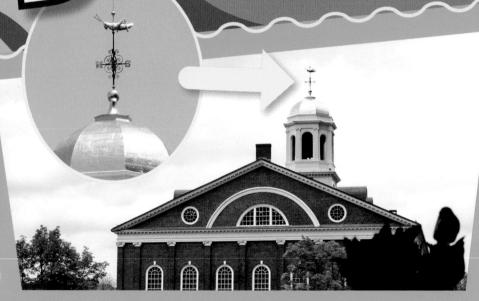

SPY TEST

Built in 1742, Faneuil Hall has always been an important meeting and marketplace for Boston. Legend claims that the famous grasshopper weather vane on top of the building started serving as a "spy test" around the time of the Revolutionary War. In those days, anyone who couldn't answer the question "What is on top of Faneuil Hall?" probably wasn't a local resident and could be considered suspicious

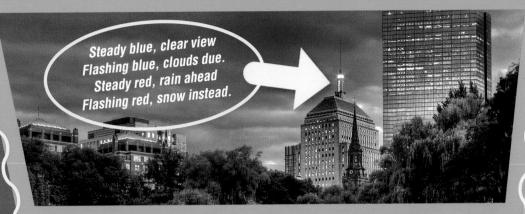

WEATHER BEACON

The lights on top of the Berkeley Building (formerly known as the John Hancock Building) aren't just for decoration. The color and the flashing of the lights provide a weather forecast. The poem above cracks the code. In the summer (when there's no snow), flashing red means that a Red Sox game has been rained out.

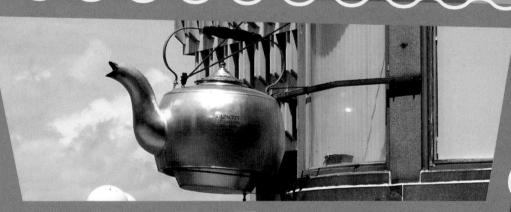

MORE THAN A CUP

On January 1, 1875, a contest was held to guess how much liquid this giant teakettle (that still hangs on a storefront in downtown Boston) would hold. More than ten thousand people watched the official measuring. Turns out the kettle holds 227 gallons, 2 quarts, 1 pint, and 3 gills (a gill is about a quarter of a pint). Eight people gave guesses close enough to win. Their prize? Five pounds of tea!

Boston:

Tonikers arvelous arvelous arvelous arvelous arvelous arvelous

What's a moniker? It's another word for a name...and Boston has plenty of interesting monikers around town!

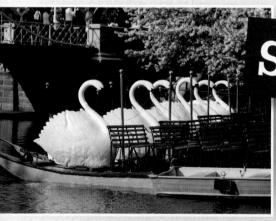

Swan Boats

A Springtime Name

For more than 130 years, the launch of the **Swan Boats** at the Boston Public Garden has signaled the arrival of spring.

The North End

A Tasty Name

One of Boston's oldest neighborhoods, the **North End**, is known for its excellent Italian food—including gelato, a frozen Italian dessert.

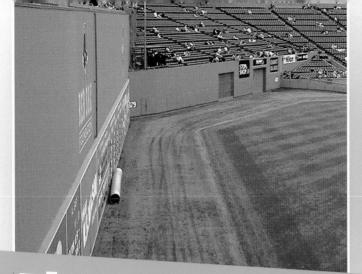

A Home Run Name

The left field wall at Fenway Park measures 37 feet high. Called the **Green Monster**, it's famous for preventing home runs on hits that would've cleared the lower walls at other ballparks.

The Green Monster

Museum of Science.

Museum of Science, Boston

A Name for Discovery

The **Museum of Science**, **Boston** is home to one of only four nearly complete Triceratops skeletons in the world!

Bahston

A Classic Accent

A **Bahston** (or Boston) accent has a wonderful sound! The most memorable words often involve the letter "r" as in: *Yah faatha pahkd the cah in the yahd*. Get it?

Boston: AIVAIIC S

A GREAT Revolt!

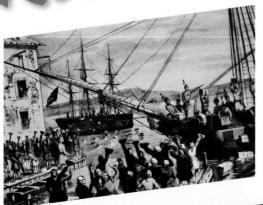

In 1773 thousands of colonists were so angered by a new tax law that they banded together to keep ships from the British East India Tea Company from unloading their tea when they arrived in the Boston Harbor. After meetings failed to settle the issue, a group of colonists (some dressed as Native Americans) boarded the ships and dumped 342 chests of tea into the harbor's water. The act was originally called the Destruction of the Tea—but it later became more famously known as the Boston Tea Party.

The BLIZZARD The BLIZZARD The BRIZZARD The BRIZZARD The BRIZZARD The BRIZZARD The BRIZZARD

One of the worst snowstorms in Boston's history occurred on February 6 and 7, 1978. More than twenty-seven inches of snow and very strong winds made travel impossible. Thousands of cars were stranded on highways and coastal areas experienced areas are flooding. Sadly, dozens of people died in severe flooding. Sadly, dozens of people died in saverage salls of the storm, and property damage soared into the millions.

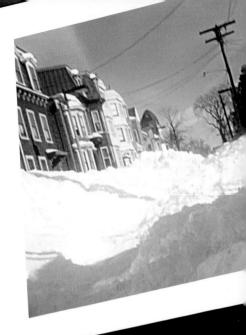

The BIG

The Central Artery/Tunnel Project—unofficially known as The Big Dig—was the most challenging highway redesign any U.S. city has ever undertaken. Lots of other construction took place, but the main objective was to reroute the elevated Central Artery (Interstate 93) into a tunnel under the city. At the peak of the project, about five thousand workers were on the job. Construction began in 1991...

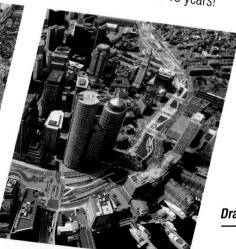

Dramatic Days

There is a lot to see and celebrate...just take a look!

CONTENTS

Commonwealth of Massachusetts.

Land	pages 2-9
History	pages 10-17
People	pages 18-25
And a Lot More Stuff!	pages 26-3

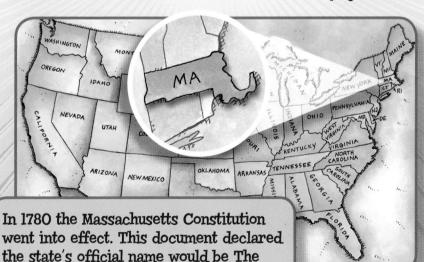

What's So Great About This State?

Well, how about... the land!

From the Eastern Shores...

Massachusetts is one of six states that form the New England region of the United States. (Maine, New Hampshire, Vermont, Rhode Island, and Connecticut are the other five states.)

Around 20,000 years ago, glaciers still covered the land. As the climate warmed, the glaciers slowly retreated leaving interesting landforms and a roller coaster of elevations, or land heights.

At sea level, natural harbors create safe ports along the eastern coastline. Peninsulas, such as Cape Ann and Cape Cod, jut out into the water. Wind and waves surround both big and small offshore islands.

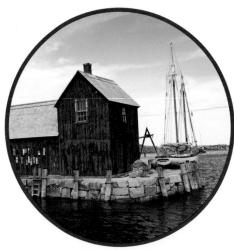

This fishing shack in Rockport, a village on Cape Ann, has been used in so many photos and paintings that it is now famously called Motif No. 1.

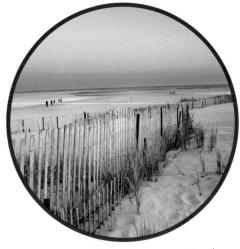

Hundreds of miles of shoreline make the Cape Cod beaches very popular vacation spots in summer.

...to the Western Hills

As you move away from the coast and further inland, the land begins to rise into the hills and mountains of the Eastern Upland region. But not for long! Elevations fall into the Connecticut River Valley when you reach the middle of the state.

The ride doesn't stop there. Western "Mass" is home to the Berkshire Hills and Mount Greylock, which—at 3,491 feet—is the highest point in the state.

It's quite an adventure to explore the land across Massachusetts. Turn the page to see just some of the interesting places you can visit throughout the state!

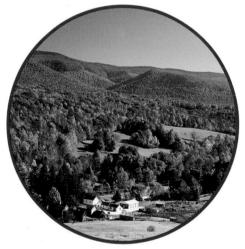

Western "Mass" is home to the Berkshire Hills, which blaze with color in the fall.

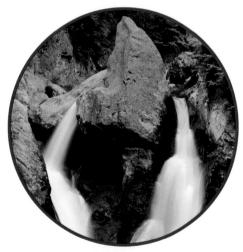

In the southwestern corner of the state, a huge boulder splits the water into two sections at Bash Bish Falls.

The Coasta Coasta Lowland Coasta Low And Coasta Low

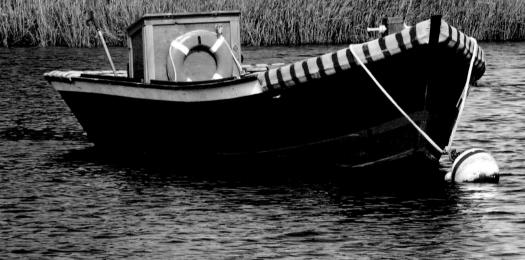

A small fishing boat floats in marshy waters on Cape Cod.

The Coastal Lowland region covers one third of the state and extends all the way to the Atlantic Ocean. This region also includes islands off the coast, such as Plum Island, the Elizabeth Islands, Nantucket, and Martha's Vineyard.

What's so special about the Coastal Lowland region?

Even though the land is mostly low-lying, there are many interesting things to see. Small oval-shape hills, or drumlins, are the calling cards of ancient glaciers in some parts of this region. Marshes, small lakes, and ponds also dot the landscape. Beautiful beaches and natural harbors are common sights along the coast.

...and there's more!

The Cape Ann peninsula along the northern coastline requires six lighthouses to keep ships safe from its rocky shores. Along the southern coastline, huge sand dunes at the Cape Cod National Seashore offer a lookout for ocean-going whales.

Plum Island is one of the barrier islands along the state's northern shore. It lies close to the mainland and shields coastal beaches from wind and ocean waves. But Massachusett's most famous islands—Martha's Vineyard and Nantucket—sit farther away from the mainland off the southern coast of the state.

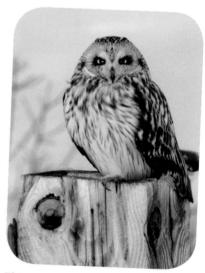

This owl is not bothered by winter snow along the northern coast of the state.

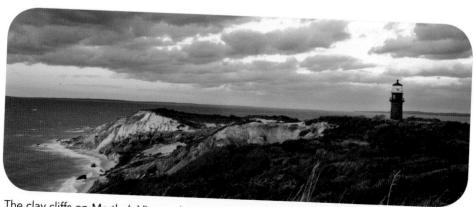

The clay cliffs on Martha's Vineyard are constantly pounded by ocean waves.

VALLEY EASTERN UPLAND

This barn stands in the Pioneer Valley area of the Connecticut Valley I owland region

Just west of the Coastal Lowland, the Eastern Upland begins. The land rises up to 1,000 feet above sea level in this area. Skiers and hikers love the trails and beautiful views of the hills and mountains in this region.

Then the land takes a dip!

Just west of the Eastern
Upland region, the land
begins to slope down to the
Connecticut Valley Lowland
region. The Connecticut River
flows through the valley. Some
of the best soil in the state can
be found in this region so it's
a good place for farmers to
grow fruit and corn and raise
livestock.

Don't forget the Western Upland!

Continue into the Western Upland region and the land begins to rise again. The Berkshire Hills are covered in thick forests. Freshwater streams provide homes for fish, muskrat, and beaver.

Just west of the Berkshire
Hills (before you get to the far
western Taconic Mountains)
lies the Berkshire Valley. This
narrow valley —only ten miles
at its widest—runs the whole
length of the state and is a
prime location for grazing
cows and dairy farms.

Glaciers left loads of rocky debris on Massachusetts land so it's common to see walls and fences fashioned from stones rather than wood.

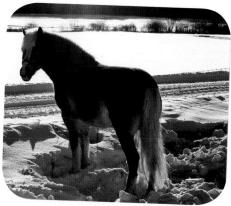

Cows aren't the only critters raised in western Massachusetts, as this snow-covered horse farm shows!

Stockbridge is one of the many beautiful towns in the Berkshire Hills of western Massachusetts.

Ponds, Lakes, and Rivers

New England's longest river, the Connecticut River, flows north to south through Massachusetts.

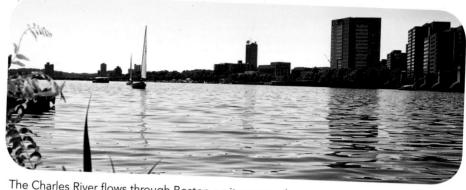

The Charles River flows through Boston on its way to the Atlantic Ocean.

Massachusetts has thousands of miles of rivers and streams flowing throughout the state. Several major rivers include the Charles, the Connecticut, the Merrimack, and the Housatonic. But that's not the end of the water resources. The state has more than three thousand lakes and ponds—some of which are kettle ponds.

What's a kettle pond?

Glaciers at work again! As huge chunks of ice retreated from the land ten to twenty thousand years ago, they carved holes in the land's surface, forming many of the state's lakes and ponds. However, kettle ponds were created just a little differently. They formed when buried blocks of ice melted, causing the sand and gravel above them to collapse into a hole.

Walden Pond, made famous through the writings of Henry David Thoreau, is probably the most famous kettle pond in Massachusetts.

Why are lakes, rivers, and ponds so special?

That's an easy one! These water resources provide recreation, transportation, food, and habitats. Most important, they supply

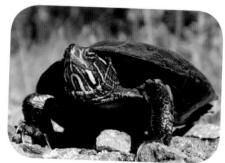

Lots of different wildlife, including this painted turtle, live at Walden Pond State Reservation.

drinking water. In fact, the largest lake in Massachusetts is an artificial lake called the Quabbin Reservoir. It was built in the 1930s to help meet the freshwater needs of the capital city of Boston and surrounding communities.

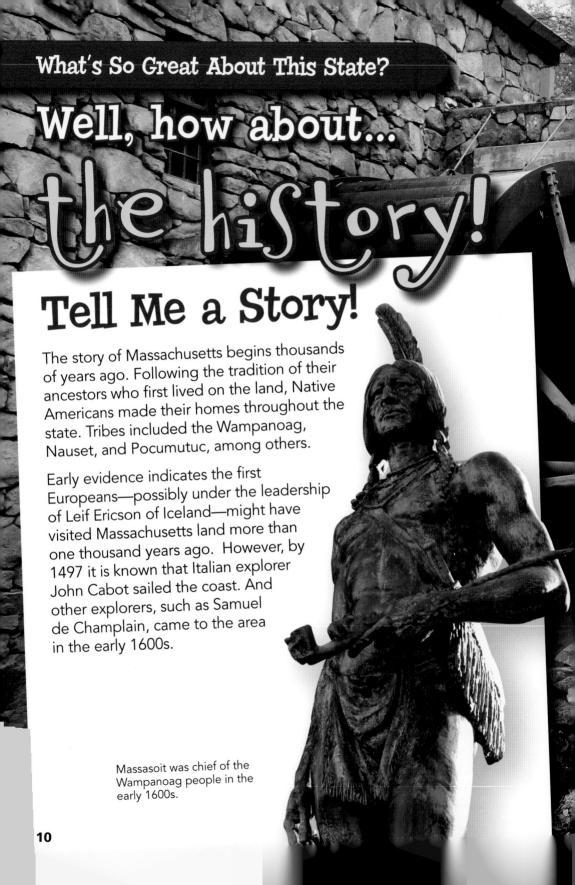

...The Story Continues

The first European settlers who came with their families to stay arrived in 1620, from England. About one hundred passengers from the Mayflower came ashore at what is now called Plymouth. Many of the passengers were Church of England Separatists—a group who became known as the Pilgrims. In 1630, a large wave of people from a different religious group, called the Puritans, arrived from England to settle as part of the Massachusetts Bay Colony.

Eventually, Massachusetts became home to many other people. Their footprints are stamped into the soul of Massachusetts history. You can see evidence of this all over the state!

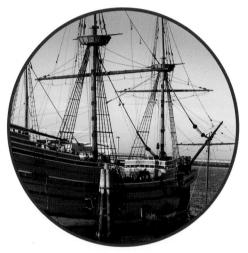

The Mayflower II at Plimoth Plantation is a replica, or copy, of the small wooden ship that crossed the Atlantic Ocean in 1620. Imagine what it would've been like to travel with farm animals and one hundred other people over the open ocean—for two months!

The first battles of the American Revolutionary War were fought in Lexington and Concord in April of 1775. (This is when Paul Revere made his famous ride to warn that the British were coming.)

Monuments

Bronze statues in Springfield, Massachusetts, honor Dr. Seuss and some characters from his books.

Monuments, memorials, and historic sites honor special people or events. The Dr. Seuss National Memorial in Springfield honors hometown author Theodor Seuss Geisel—better known as Dr. Seuss!

Why are Massachusetts monuments so special?

That's an easy one! Many special people helped build the state of Massachusetts. Some, like politicians and presidents, were famous when they lived. Others became better known over time. Paul Revere is a good example! This hero of the American Revolution rode on horseback throughout the night to warn people of a British attack. His alert helped save John Hancock and Samuel Adams from capture. Statues honor Revere's bravery, and Henry Wadsworth Longfellow spread his fame by paying tribute to Revere's famous midnight ride in a well-loved poem.

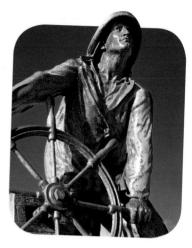

The "Man at the Wheel" statue in Gloucester is dedicated to fishermen who have been lost at sea.

What kind of monuments can I see in Massachusetts?

There are many different kinds. From statues to bridges, almost every town has found some way to honor a historic person or event. Even street signs often show the name of someone special.

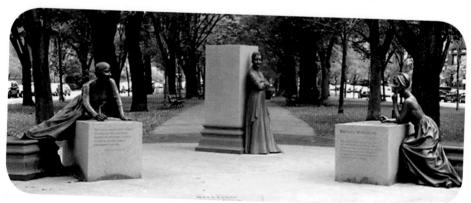

The Boston Women's Memorial on the Commonwealth Avenue Mall honors three women who made important contributions to the history of Massachusetts—Abigail Adams, Lucy Stone, and Phyllis Wheatley. The sculptor, Meredith Bergmann, purposely shows the women using their pedestals...not standing on them!

Museums

The USS Constitution was first commissioned in 1797 and it is still part of the U.S. Navy fleet.

Museums tell you about history in such interesting ways! At the USS Constitution Museum in Boston you can learn about the three-masted Navy vessel that is nicknamed "Old Ironsides." You can also learn what the life of a sailor was like in the early 1800s—from furling sails to scrubbing the decks.

Why are the museums in Massachusetts so special?

Museums tell many different stories. The Norman Rockwell Museum in Stockbridge has the largest collection of Rockwell paintings in the world. This famous American artist painted scenes showing the daily life of people—including many who lived near him in the Massachusetts Berkshire region.

What can I see in a museum?

An easier question to answer might be "What can't I see in a museum?" Of course, different museums have different artifacts, or objects. The Museum of Fine Arts in Boston has about 400,000 pieces of art, ranging from Egyptian mummies to Native American pottery. The Spellman Museum of Stamps and Postal History in Weston holds more than two million artifacts that give a historical view of the country and promote the hobby of stamp collecting.

This stamp celebrated the state of Massachusetts—back when postage was only 37 cents!

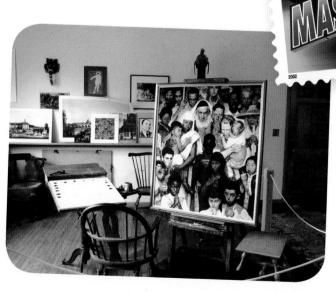

At the Norman Rockwell Museum you can see the studio where the artist worked. The painting shown here, called *The Golden Rule*, was a famous *Saturday Evening Post* magazine cover in 1961.

Forts

Fort Independence is on Castle Island in the Boston Harbor. The first fort on Castle Island was built by the British. However, the fort was given its current name—Fort Independence—after Americans had won independence in the Revolutionary War. The present-day fort (the eighth one built on the site) is a state park.

Why are forts special? (...and what is a fort, anyway?)

A fort is a defensive structure built for troops. Forts played important roles in the struggle for independence in the early history of our country.

The inside of a fort was often a self-contained community. That's because soldiers often had to stay inside the fort during long attacks.

A fort had barracks—places for soldiers to sleep—as well as kitchens for water and food supplies. Forts even had repair shops to keep battle equipment in top shape.

What can I see if I visit a fort?

Some forts show you what life was like long ago. You can see artifacts, including cannons and other weapons soldiers used. Other forts are now peaceful parks where you can walk and sightsee.

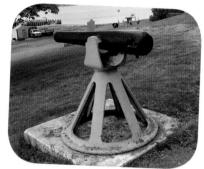

A cannon used in the Civil War still stands at Fort Warren on George's Island, which is now part of the Boston Harbor Islands National Recreation Area.

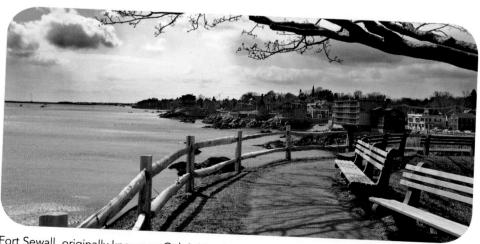

Fort Sewall, originally known as Gale's Head, was renamed to honor Marblehead native and Massachusetts Supreme Court Justice Samuel Sewall. The fort is now a park with beautiful views of the Marblehead Harbor.

What's So Great About This State?
Well, how about...
The people

Enjoying the Outdoors

More than six and a half million people call Massachusetts home. As hearty New Englanders, Bay Staters know that harsh winter weather sometimes brings challenges. However, most have a deep respect for the land and share a love of the outdoors.

With four distinct seasons, people in Massachusetts can enjoy different activities all year long. Skiing in the winter, rafting in the spring, swimming and hiking in the summer—the list of things that Bay Staters enjoy goes on and on!

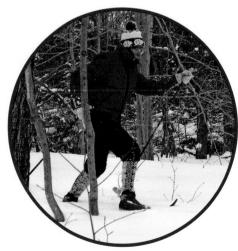

Cross-country skiing provides a winter workout in the Berkshire area of western Massachusetts.

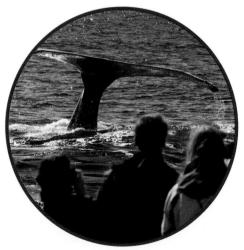

Whale watching is popular off the coast of Massachusetts from spring through fall.

Sharing Traditions

Massachusetts is rich in traditions. You can find evidence of this all over the state. Re-creations of distant battles honor brave soldiers. Interesting festivals showcase skills (from quilting to repairing fishnets) that have been passed from one generation to the next.

Cooking is another way to pass on traditions. Portuguese, Italian, Irish—the tasty dishes served on tables throughout the state come from many different cultures. Locally grown food, like cranberries and apples, are used in many recipes. Freshly caught oysters, clams, cod, and lobsters also add to the tasty mix.

You can learn 17th-century English at Plimoth Plantation. Instead of saying "Congratulations," the English colonists might have said "Huzzah!"

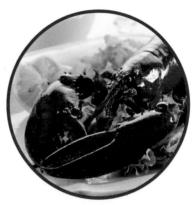

Cracking open a freshly cooked lobster requires practice...and a large bib!

Protecting

A yellow warbler perches on a branch at the Parker River National Wildlife Preserve in Newburyport. The Parker River National Wildlife Preserve was originally opened to provide feeding, resting, and nesting habitats for migratory birds. Today, the refuge's mission is even greater as it helps protect threatened and endangered species in the state.

Why is it important to protect the natural resources of Massachusetts?

Although the state of Massachusetts is not very large, it still has plenty of different environments within its borders. All these different environments mean lots of different plants and animals live throughout the state. In technical terms, Massachusetts has great biodiversity. This biodiversity is important to protect because it keeps the environments balanced and healthy.

What kinds of organizations protect these resources?

Protecting all of Massachusetts's natural resources is a full-time job for many people! State organizations such as the Massachusetts Department of Conservation and Recreation and the Massachusetts Department of Environmental Protection work to manage, protect, and preserve the state's natural resources and heritage. Of course, there are many other private groups at work, too, such as the Massachusetts Audubon Society and the Rachel Carson Council.

And don't forget...

You can make a difference, too! It's called "environmental stewardship"—and it means you are willing to take personal responsibility to help protect Massachusetts's natural resources.

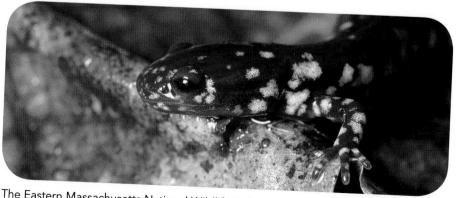

The Eastern Massachusetts National Wildlife Refuge Complex has a Citizens Science Program. So if you see a rare animal on refuge land, like this blue-spotted salamander, the staff wants you to report it. They will then add the sighting to their records, which helps their conservation efforts.

Creating Jobs

Cranberries are harvested in the bogs of southeastern Massachusetts.

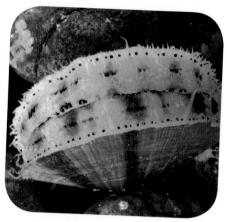

New Bedford is famous for its yearly harvest of sea scallops.

Many jobs in the state require research skills.

Military training is hard work!

Some jobs have been done in Massachusetts for a long time. Farming is one of them. Fishing along the Atlantic coast is another. Other jobs—in research and technology—are newer to the state.

What other kinds of work do people do throughout the state?

Manufacturing, or making things, is common. Years ago, textile manufacturing (basically, making cloth) was very big. Today, however, computer equipment and plastic products are more likely to be produced.

Many people also now work in the finance industry. Health care and education are also in demand.

Technology service positions require computer programmers and engineers. The tourist industry also needs service providers. It takes a lot of workers to help people sightsee, eat, and relax!

Don't forget the military!

The Air Force, Army, Marine Corps, Navy, and Coast Guard can all be found in the state. The people of Massachusetts have great respect for all the brave men and women who serve our country.

celebrating

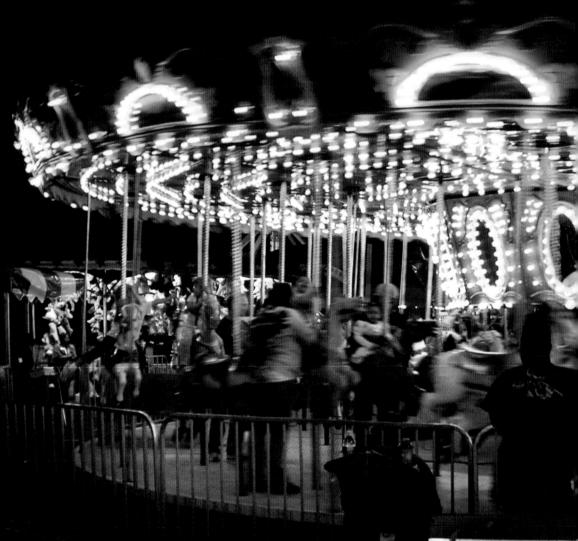

The carousel ride is great fun at the Big E in West Springfield.

The people of Massachusetts really know how to have fun! West Springfield is home to the largest fair in New England—the Eastern States Exposition. Called the Big E, it attracts more than a million people each year to enjoy everything from rides and music to animal exhibits and food.

Why are Massachusetts festivals and celebrations special?

Celebrations and festivals bring people together. From cooking and farming to arts and entertainment, special events across the state celebrate the people of Massachusetts and their talents.

What kinds of celebrations are held in Massachusetts?

Too many to count! But one thing is for sure. You can find a festival or celebration for just about anything you want to do.

Do you like pig races? You can cheer for your favorite porker at the Martha's Vineyard Agricultural Fair.

Or maybe you'd like to sample some interesting new types of food? The Lowell Folk Festival celebrates food and music from all over the world.

... and don't forget the skillet toss!

Skillet tossing is a popular contest for both men and women at the Festival of the Hills in Conway. How does it work? Just like it sounds! Whoever tosses a heavy skillet the farthest wins!

You can hear great music at the Salem Jazz and Soul Festival.

Pie-eating contests—like the kind they have at the Truro Agricultural Fair—can produce results like this!

What do all the people of Massachusetts have in common? These symbols represent the state's shared history and natural resources.

State Bird
Black-capped Chickadee

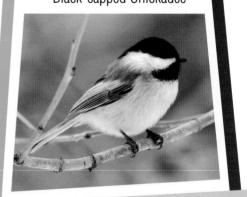

State Flower
Mayflower

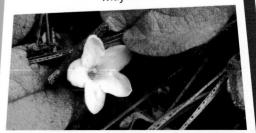

State Berry Cranberry

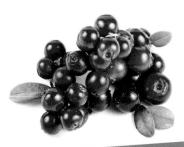

State Reptile
Garter Snake

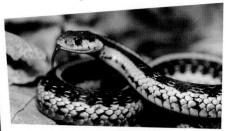

State Horse

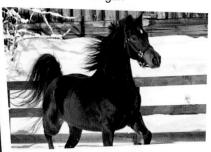

State Flag

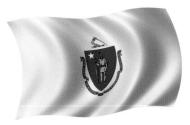

State Game Bird

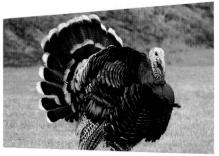

State Muffin

Want More?

Statehood—February 6, 1788 State Capital—Boston State Nickname—The Bay State State Song—"All Hail to Massachusetts" State Sport—Basketball

State Beverage—Cranberry Juice State Fish—Cod State Mammal—Right Whale State Dance—Square Dance State Cookie—Chocolate Chip

More

Here's some more interesting stuff about Massachusetts.

A Tribal Name

Massachusetts takes its name from the Massachusett tribe of Native Americans, who lived south of Boston in the Great Blue Hill area.

A Presidential County

Four U.S. presidents were born in **Norfolk County**: John Adams, John Quincy Adams, John Fitzgerald Kennedy, and George Herbert Walker Bush.

A Whale of a Tale

In 1841 Herman Melville sailed out of **New Bedford** on a whaling ship. Years later, while living in **Pittsfield**, he wrote his most famous book, called *Moby-Dick*. However, the book was not considered a huge success until many years after his death.

An Apple a Day

Johnny Appleseed (whose real name was John Chapman) was born in **Leominster** in 1774.

A Yearly Tea Party

The reenactment of the Boston Tea Party takes place at the Old South Meeting House in Boston each year.

A Primary Park

Boston Common (in **Boston**, of course!) is the oldest public park in the country. It was established in 1634.

How Sweet It Is

The fig newton was named after the city of **Newton**.

"Southie" Irish Spirit

St. Patrick's Day is a popular celebration in Massachusetts. The **South Boston** St. Patrick's Day Parade has been a tradition since 1901.

Be Happy!

Harvey Ball of **Worcester** designed the world-famous Smiley face.

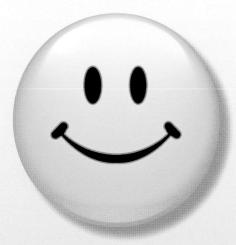

The Belle of Amherst

Emily Dickinson wrote nearly 1,800 poems. But fewer than 12 of them were published in her lifetime.

A Yummy Creation

Ruth Wakefield, who—with her husband—owned the Toll House Inn near **Whitman**, is credited with inventing the chocolate chip cookie in the 1930s.

A Peach of a Game

In 1891 **Springfield** physical education teacher James Naismith invented the game of basketball. The first game was played with a soccer ball using two peach baskets as goals.

The Original Volley

The Volleyball Hall of Fame is in **Holyoke**—where the game was first invented by William G. Morgan in 1895. Morgan originally called his new game Mintonette.

Lobster Lure

In 1808 Ebenezer Thorndike invented the lobster trap in the seaside town of **Swampscott**.

A Smart Spot

In the Five College Ārea of Pioneer Valley (also called the Connecticut Valley), five institutions—the University of Massachusetts-Amherst, Hampshire College, Smith College, Mount Holyoke College, and Amherst College—are located within minutes of each other.

A Sports Frenzy

Massachusetts is home to many professional sports teams including the Boston Celtics, Boston Bruins, New England Patriots, Boston Red Sox, and the New England Revolution. In addition, all the great college and university teams bring delight to their fans!

A Famous Little Woman

Louisa May Alcott wrote her classic novel, *Little Women*, in **Concord** in 1868.

Well Read Kids

In 1895, the Boston Pulbic Library was the first to open a special section for children.

Final Out More

There are many great websites that can give you more information about the exciting things that are going on in the state of Massachusetts!

State Websites The Official Website of Massachusetts www.mass.gov

Massachusetts Department of Conservation and Recreation www.mass.gov/dcr

Museums/Boston John F. Kennedy Presidential Library and Museum/Boston www.jfklibrary.org

Massachusetts Museum of **Contemporary Art** www.massmoca.org

Museum of African American History (Boston and Nantucket) www.afroammuseum.org

Museum of Fine Arts www.mfa.org

Cambridge **Harvard Museum of Natural History** www.hmnh harvard.edu

Gloucester **Cape Ann Museum** www.capeannhistoricalmuseum.org

Lowell **American Textile History Museum** www.athm.org

Plymouth **Plimoth Plantation** www.plimoth.org

Springfield **Basketball Hall of Fame** www.hoophall.com

Stockbridge Norman Rockwell Museum www.nrm.org

Weston **Spellman Museum of Stamps** and Postal History www.spellman.org

Aquarium and Zoos **New England Aquarium (Boston)** www.neag.org

Franklin Park Zoo (Boston) www.zoonewengland.org

The Zoo in Forest Park and **Education Center (Springfield)** www.forestparkzoo.org

Southwick's Zoo (Mendon) www.southwickszoo.com

Stone Zoo (Stoneham)

www.zoonewengland.org

Massachusetts: At A Glance

State Capital: Boston

Massachusetts Borders: Rhode Island, Connecticut, New York, Vermont,

New Hampshire, and the Atlantic Ocean

Population: 6,600,000

Highest Point: Mount Greylock—3,491 feet above sea level

Lowest Point: sea level at the Atlantic Ocean

Some Major Cities: Boston, Worcester, Springfield, Lowell, Cambridge, Brockton,

New Bedford, Fall River, Quincy, Lynn

Some Famous People from Massachusetts

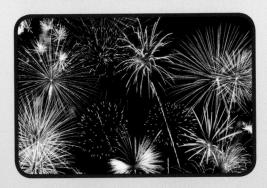

Samuel Adams (1722–1803) from Boston; was one of the Founding Fathers of the United States, Massachusetts delegate to the Continental Congress, and a leader of the American Revolution.

Susan B. Anthony (1820–1906) from West Grove; was a leader in the 19th-century women's rights movement.

Clarissa "Clara" Barton (1821–1912) from North Oxford; was a Civil War nurse and founder of the American Red Cross.

William Edward Burghardt (W.E.B.) DuBois (1868–1963) from Great Barrington; was a writer, historian, and civil rights activist. Benjamin Franklin (1706–1790) from Boston; was one of the Founding Fathers of the United States (he signed both the Declaration of Independence and the Constitution), a printer, author, inventor, statesman, diplomat, and Postmaster General first of Philadelphia and later of the government of the Continental Congress.

Winslow Homer (1836–1910) from Boston; was a landscape painter considered to be one of the most important painters of 19th-century American art.

John F. Kennedy (1917–1963) from Brookline; was the 35th president of the United States.

Sharon Christa McAuliffe (1948–1986) from Boston; was a teacher and NASA astronaut who received the Congressional Space Medal of Honor.

Barbara Walters (born 1929) from Boston; is a broadcast journalist, TV host, and author.

Sunset on Martha's Vineyard

CREDITS

Series Concept and Development

Kate Boehm Jerome

Design

Steve Curtis Design, Inc. (www.SCDchicago.com); Roger Radtke, Todd Nossek

Reviewers and Contributors

Content review: Julia J. Mize, Acting Education Specialist, Boston NHP; Contributing writers/editors: Terry B. Flohr, Stacey L. Klaman; Research and production: Judy Elgin Jensen; Copy editor: Mary L. Heaton

Photography

Back Cover(a), 271 @ Picslive/Shutterstock; Back Cover(b), 2a @ Jerry Moorman/iSlockphoto; Back Cover(c), 10a @ Marcio Jose Bastos Silva/Shutterstock; Back Cover(d), 3b @ Ralph Roach/Shutterstock; Cover(e), 18-19 @ Christian Delbert/Shutterstock; Cover(a), 2b @ Chee-Onn Leong/Shutterstock; Cover(b), 26c By Justin Russell/From Wikipedia; Cover(c), 26b @ Chas/Shutterstock; Cover(d) @ Olga Miltsova/Shutterstock; Cover(e), 14-15 @ Jennifer L. Harvey/Shutterstock; Cover(f) @ Dave Newman/Shutterstock; 2-3, 32 @ Jorge Salcedo/Shutterstock; 3a, 6-7, 7c @ Denis Jr. Tangney/iStockphoto; 4-5 @ Doug Lemke/Shutterstock; 5a, 20-21 @ Ken Canning/iStockphoto; 5b @ Mike Liu/Shutterstock; 7a @ Jeff Schultles/Shutterstock; 7b @ Bruce Barone/Shutterstock; 8-9 @ Christopher Chan; 9a @ Stephen Orsillo/iStockphoto; 9b Courtesy Massachusetts Department of Conservation and Recreation; 10-11 @ Joy Brown/Shutterstock; 11a @ Tim Gupta/iStockphoto; 11b @ Lawrence Roberg/Shutterstock; 12-13 @ 2010 Alex Tsai, flickr.com/alextsf; 13a @ Israel Pabon/Shutterstock; 13b Sculpture and photo by Meredith Bergmann; 15a By Jeremy Clowe. @ Norman Rockwell Museum. All rights reserved.; 15b Courtesy Spellman Museum of Slamps & Postal History; 16-17 By Greg Frechette; 17a, 28 @ Marcos Carvalho/Shutterstock; 17b @ Adrian LaRoque; 18a @ Allan Pospisil/iStockphoto; 18b @ Sam Chadwick/iStockphoto; 19a Courtesy Plimoth Plantation; 19b @ marco mayer/Shutterstock; 21 @ James DeBoer/Shutterstock; 22-23 @ Kenneth Wiedemann/iStockphoto; 23a By Dann Blackwood/U.S. Geological Survey; 23b @ Hywit Dimyadi/Shutterstock; 23c @ John Wollwerth/Shutterstock; 24-25 Courtesy Eastern States Exposition; 25a @ Pindyurin Vasily/Shutterstock; 25b @ David P. Smith/Shutterstock; 27b @ Pakmor/Shutterstock; 27c @ Lyle E. Doberstein/Shutterstock; 27d @ Mike Neale/Shutterstock; 27e @ canap72/iStockphoto; 29a @ VectorZilla/Shutterstock; 29b @ Sandra Cunningham/Shutterstock; 31 @ R. Gino Santa Maria/Shutterstock

Illustration

Back Cover, 1, 4, 6 © Jennifer Thermes/Photodisc/Getty Images

Copyright © 2011 Kate Boehm Jerome. All rights reserved. No part of this book may be used or reproduced in any manner without written permission except in the case of brief quotations embodied in critical articles and reviews.

ISBN 978-1-58973-019-9

Library of Congress Catalog Card Number: 2010935882

1 2 3 4 5 6 WPC 15 14 13 12 11 10

Published by Arcadia Publishing, Charleston, SC For all general information contact Arcadia Publishing at: Telephone 843-653-2070

Fax 843-853-0044

Email sales@arcadiapublishing.com
For Customer Service and Orders:

Toll Free 1-888-313-2665

Visit us on the Internet at www.arcadiapublishing.com